RAY BOOTH
THE EXPRESSIVE HOME

RAY BOOTH
THE EXPRESSIVE HOME

ARCHITECTURE
AND INTERIORS

Written with Judith Nasatir

New York · Paris · London · Milan

Table of Contents

- 6 Introduction
- 8 To Dream
- 10 To See
- 12 To Make
- 16 New Beginnings
- 50 Art and Industry
- 66 The Landscape of Home
- 86 Into the Light
- 118 Places of the Heart
- 136 Enchanting History
- 166 Mountain Magic
- 182 Reinventing Home
- 204 Dutch Treat
- 230 Local Color
- 244 Finding the Balance
- 270 Photography and Art Credits
- 271 Acknowledgments

Introduction

Every day I am reminded of what a joy it is to have a career that satisfies my need to dream, to see, and to make. I have always believed we are innately creative beings and something specific to our human condition begs us to reflect and express in our residences the evidence of what we experience, think, feel, and imagine. My awareness of the real value embodied in the process of making developed early. From childhood, I knew each act of creation had meaning. It was clear to me how shaping, guiding and seeing to fruition the physical proof of such efforts manifested in the world would bring great emotional and intellectual fulfillment. As we work to accomplish our goals successfully, however, obstacles inevitably occur along our chosen path. While my youthful attraction to architecture led me to Auburn University's renowned architecture department, the degree's mathematics and physics requirements gave me pause. At any rate, my first job after graduation in New York City was at an interior design office, which drove me to explore an entire universe of related design endeavors.

As the years passed, this Southerner in the city discovered so much. Through all this learning and growing, I cherished my relationships with Bobby McAlpine and Greg Tankersley, who, since my college days, had been friends, mentors, and, quite often, sources of inspiration. In the twenty-five years since joining their firm, McALPINE, as a partner in charge of interiors, each new client and project has expanded my sense of what is possible. I could not be more grateful. Always, though, there has been a longing for more, a thirst to tackle new challenges. I love designing interiors. And I delight in developing furniture. Yet architecture is how I see. And architecture has always been the wellspring from which my creative approach and process draws.

One tenet of our design philosophy at McALPINE is the importance of thinking deeply about human scale in every choice we make. We delve into the relationship between the individual body and the form, shape, and dimensions of a given chair; that chair's placement and type in congress with the surrounding pieces and within the confines of the room; the room's position in the flow of the plan; the way the plan sits on the site; and the site's connection to its immediate surroundings and the paths of the sun and light. All these aspects need to be in some form of balance for the individual elements and the whole to resonate so the project flourishes. Deliberating over each decision in this way—from the minute to the massive and back again—allows us endless flexibility for finding the best solution for the design challenges that the particular set of needs and constraints presents.

Building two homes for my husband, John Shea, and myself reinforced the relevance of this philosophical approach to architecture, interior design, and furnishings. Each house came with its unique program, specific to us and our needs at the time. We looked at our site's poetry of place and other aspects of its character. Then we analyzed how we could build to create a sense of belonging, considerations essential to every project, and what I strive to derive and address for each client and their home.

This personal experience has given me deep empathy and a vast appreciation for how our clients feel when they come to us to make their dreams, desires, and aspirations manifest in their residences. The most important lesson I have learned is this: Tackling the challenges and solving the riddles of building requires trust and faith in a process that can be long, difficult, and full of the unexpected. For this reason, faith and trust—whether given by oneself or endowed by the client—are among the most valuable assets of all to have on any project.

Most of us, no matter what our career pursuits, know creative hunger, the craving that seems to compel us to explore, evolve, and grow, to learn new things, to expand the parameters of our skills. It is this drive to reach further and continue to develop those roots that *The Expressive Home* presents. A number of the residences in these pages offer glimpses into homes I have been fortunate enough to create for clients from the inside out, from the outside in, and from the foundations up—in other words, architecture and interiors designed together from concept to completion—as well as several existing homes I reimagined and renovated for clients inside and out. Still other projects celebrate the interiors I crafted for the houses my partners at McALPINE have designed.

My goal here is to shed light on my own and my partners' evolving abilities, and to answer some questions about my approach to all things design. Every successful project transcends the process of shaping and selecting individual pieces and parts to cohere into a warm, inviting, life-enhancing residence. When this happens, each aspect of the design resonates with all the others, with the client, and with the surroundings that have helped shape it. This is what I call "the expressive home."

To Dream

So many people have a love of design, architecture, and interiors. They, like me, have a dream, often many dreams, of what their ideal home should, would, and could be. They—and I, too—celebrate when the opportunity arises to build the long-cherished fantasy into beautiful, three-dimensional form. But there is a "but": Dream homes fit the moment, but the moment always moves on. Because a home is such a substantial investment, it is key to imagine the future into the planning process for the present so the living spaces can adapt to shifting needs as life evolves.

Our dreams, after all, rarely stay the same as we progress through the decades. In a way, this means that the "forever" house is truly a rare thing. Circumstances change. Families grow and move. Kids fly the nest. The third generation arrives. This is why it matters so very much to balance what's best, most necessary, and most expressive for the current life stage while also eyeing what's coming next. As paradoxical as it seems, we may get closer to the home of our dreams by analyzing the essentials and keeping the wilder ideas in check.

From the time I was a child, I have had the desire to create: specifically, to make space and effect change in environments for living. My own dream has always been to build, but this aspiration has evolved over the years in interesting ways, and especially recently as I have been fortunate to design and decorate my clients' homes in their entirety, with architecture and interiors conceived together. My early years spent furnishing interiors progressed to countless gut renovations and additions that involved reimagining living spaces for a given client and the individual lifestyle and ultimately to then creating clients' primary and secondary homes from conception to completion from scratch. In retrospect, it is so clear now each project was not just an incubator for evolving ideas about living, but a reflection of the emerging collaboration with the client, of who we were in the process of becoming, and of how their needs were graduating in various ways as their lives, careers, and families developed, deepened, and progressed. The challenge from the start, though, as in every project, was to listen to the various needs, wants, and wishes, and to make sure to represent all equally in the domestic world we were constructing together through the design development and construction process.

As we age, continuing to dream provides one of life's joys. But trying to boil down our aspirations to what is essential and thinking deeply about what is a must, what is a maybe, and what suits us now are what bring us happily home in the end.

To See

Our perceptions, dreams, and desires are dynamic, as are our wants and needs. It is fun to picture all the permutations of what could be, especially with practically everything we can imagine now just a touch away. What serves us well and brings us joy, though, inevitably evolves as we mature. It is important to ask in each of life's phases what we feel is essential in our surroundings to experience the well-lived life we imagine for ourselves. Homes, after all, are rarely one and done for any of us.

The process of envisioning a home that expresses a client's unique personality takes in the tangible and the intangible. To ensure seeing and believing are in alignment requires close collaboration. What resonates in the end is a mysterious alchemy of practical, pragmatic strokes and nuances to enhance each moment of daily living in balance with the philosophical insights that drive the individual solutions. Images and inspiration go hand in hand from the early, exploratory phases of inception and conception to the emergent array of possibilities and potentialities. As clarity increases, choices gradually crystallize into the realities of form, function, material, texture, color, ornament, and art. Place is inevitably a wellspring for what follows, and often sparks an evaluation into the calculus of wants, necessities, and wishes.

The better choice may call for setting aside one desire to bring all the others home. For that reason, I tell clients early on that editing is the key to happiness. Interior design and architecture at their best, bring clarity and comfort, both visual and aesthetic, through form and function. When clients want a home that accommodates all their needs, wishes, and dreams, it is time for a gentle reminder that this may not necessarily result in the most desirable solutions, as paradoxical as that may seem. If we can analyze and simplify the project's real needs early on, then we can reap the benefits of conserving resources—time, energy, and emotion not least among them—as the project progresses. This is just one reason why the first programmatic exercise we do for each project is a written description of all the rooms each client needs and wants, as well as the functions that require attending. These lists tend to grow very long.

The lesson I have learned from a lifetime of editing confirms this bit of wisdom passed on through the ages: Just because you can, does not mean you should. Tightening the parameters often results in happier, more beautiful, outcomes. Focusing on the must-haves frees up resources to successfully produce the rich, layered home of one's dream. In setting parameters, we see possibilities. And less blooms into more.

To Make

To build a castle in the sky is one thing. To make a home, though, takes facts, even if it begins, and hopefully ends, with a dream. Completing any project, be it furnishing, decorating, interior renovation, interior architecture, architectural renovation or new architecture, requires that we tether it to reality. The process is interrogatory in its way. We analyze and scrutinize, scaling down each aspect and facet of the design to its smallest increments, then seeing how the domino process of the interactions involved to complete them plays out in the timeline. It is an exercise akin to complex calculus, but it allows us to set our decision-making within the most pragmatic, practical parameters.

Where do we begin? At the beginning. We start at that one spot, the stick in the dirt, so to speak, that will inform every other decision. Then we figure out each next step, one after the other. All the countless decisions relate to this greater truth, the seed of the idea that we're working to expand upon as we pull the concept into reality element by element, line by line, detail by detail. The same holds for the stuff of the world we are creating—the forms, shapes, materials, textures, and colors that will convey the emotional content the client, and the design itself, need and want.

But that first stake in the ground? It relates back to that castle in the sky, because it is born out of our discussions of each client's dreams, and how they see themselves living. The goal is to make sure each client feels well placed within their house, the house addresses their concerns and attends to what they most want out of their life. These basics, these essential wants and needs, feed us as we make each decision.

From the time I was a kid and had some understanding of the world, I focused on the various aspects of home, space, and creating. In our living room, in my youngest years, I would turn over furniture to build environments I could inhabit and dwell in. When I visited my grandparents, I would take over their den to create blanket forts where my cousin and I could bunk down for the night. These movable feats of making and doing evolved into drawings of imagined abodes inspired by the actual houses my mother and I had seen on car rides—not documentary sketches, but my own interpretations that assembled elements of architecture we had seen into something new. When, years later, I joined McALPINE as an interiors partner, I knew I would eventually come full circle. I have known for decades that architecture and interiors go hand in hand in the most expressive homes. Having the opportunity now to make the vision real from conception to completion? Gratitude does not begin to cover it.

New Beginnings

Change is an ongoing life lesson. In so many ways, it is also the starting point and the end point of each design. This Nashville property, which we created and decorated from the ground up for our client, a transplanted Chicagoan, gives a glimpse of how a life pivot may manifest fully in a dwelling. We wanted the form, flow, and furnishings throughout the main house, pool house/guesthouse, and garage/party barn to emerge from this client's gregarious, inclusive identity. A white-painted brick exterior was our sole aesthetic directive. To endow the main house with a distinctive personality since white-painted brick is typical in this region, we sandwiched a handmade light-colored brick masonry main core between white wood flanks and topped the entire complex with a cedar-shake roof.

The ground floor is a world unto itself with living spaces and the client's primary suite. She loves to cook and delights in entertaining, so we made the kitchen the actual center of the floor plan; from the lofty entry to the back porch and grounds beyond, spaces flow in axial alignment on either side of this hub of warmth.

The living room proper brings home the understated but luxurious blend of materials, textures, finishes, and furnishings that give all the rooms their due. With three principal seating areas, this expansive space celebrates comfort and conversation when it is chockablock, and when it is not. A front sitting area with a low, custom tête-à-tête occupies the box bay window that anchors the chief interior axis. Steps away, the television room has a comfortable sofa large enough for all the generations to pile on cozily.

The dining room opens from the living room into a kitchen designed for cooking and gathering. From the island, the client can survey her domain all the way past the front box bay window and beyond. Facing the other direction, she can communicate with company through a giant pull-up window to the screened porch that provides another gracious living and entertaining space. A sitting area with a fireplace and heaters in the ceiling allows the client to extend the indoor/outdoor season a bit beyond its regular boundaries.

We wanted her primary suite to be of air and light—and completely serene. Sheathed in silk wall covering, swathed in linen drapes, and washed in soft greens and blues pulled directly from her private garden just outside, it seems to shimmer ethereally under its beamed, vaulted ceiling.

Guest rooms, a second primary suite, and the client's office are upstairs, while the lower level houses a recreation room. The homeowner requested that the upstairs bedrooms be as beautiful for her guests as possible, which set us free to give each room its own spirit through the decor. In one, textured handmade paper gives the walls a palpably rich presence, and a custom screen gathers the bedside tables into the bed. We drenched another of these guest rooms in a warm shade of rust and installed a flight of butterflies above the headboard. In still another, a revelry of handpainted wallpaper brings two side walls to captivating life. The primary suite on the upper floor, akin to its ground-floor counterpart, reposes under a vaulted ceiling with grass-cloth-wrapped walls.

Creating a place that will be a homestead of sorts in many people's lives is a special type of heartfelt challenge. It is an honor to be able to bring this deep dream into being through, and with, design.

Pages 14–15: In architecture, materials can—and very often do—convey meaning through the perceived power of suggestion. To endow the entirely new construction of this Nashville home with the air and ambience of lived history, the brick cladding presents itself with a somewhat aged, weathered visage. This permits the central core to read as an older structure, with the wood-planked wings seeming to emerge as later additions. *Page 17:* Placing the main door on a corner or side of a house allows for a particularly inviting arrival and entry experience, one processing progressively through a sequential series of spaces to a distinctive destination. *Opposite, above, and right:* The extra-wide pivoting main door, lacquered a high-gloss green to connect it with the landscape, opens onto a glass entry hall with a view straight through to the landscaped grounds beyond. Glass passageways attach the central core seamlessly to the side buildings and afford the visual merger of the house into its surroundings. In a gracious greeting, a stone console table grounds the entry vestibule.

Pages 20–21: The great room's varied ceiling treatments differentiate seating areas. The furnishings attend to the comfort of both intimate and large groups; small perch chairs can float in between the conversation areas, adding flexibility for entertaining. The marble bolection molding draws focus to the fireplace. *Pages 22–23:* A custom tête-à-tête nested in the box bay window keeps sight lines open to the exterior and interior landscapes. *Pages 24–25:* The central kitchen connects the great room to the screened porch; the pass-through window provides easy access for serving and conversation. Symmetrical counters at seat height beckon to all during meal preparation. *Pages 26–27:* A book-matched backsplash of durable quartzite adds scenic interest beneath the custom, blackened-steel hood. *Opposite:* The central dining area flows off the kitchen just adjacent. *Above:* The dining area's custom, wall-hung bar injects a pop of color when its silvered glass doors are open. *Right:* On the opposite wall, a buffet beneath an artwork by Carolyn Quartermaine offers handy storage space.

Left, below, and opposite: The goal for this expansive screened porch was to accommodate all the aspects of indoor living other than sleeping within a luxuriously comfortable, quasi-out-of-doors setting. As a result, the generously proportioned space encompasses gracious areas for dining and lounging—including a gathering spot for conversation around a fireplace flanked by wood storage units echoing those within—as well as another kitchen. The pull-up bar adjacent to the interior kitchen affords easy, open communication between the two connected environments through the oversize window the client leaves open when the season suits. Skylights enhance the porch's architectural logic as well as the flow of ambient light and overall feeling of airiness. *Following spread:* The pool house lines up on axis with the pool, exterior lounge area, and screened porch, tying both buildings organically into the grounds that extend off the house and its several outbuildings, which, with the collaboration of landscape architect Michael Kaiser, serve essentially as a family compound.

Opposite: In this house, glass serves more than just one purpose. It frames the views in the form of windows, and it also creates the transparent connective tissue between the interior's various public and private zones. *Right:* For an interesting play of access and closure, the primary bedroom's overscale plank-wood doors, which add a feeling of gravitas to the mix of pales and neutrals, line up precisely with the box bay window that extends this room visually into the carefully considered private garden beyond. A sofa for reading, lounging, and quiet contemplation nests nicely into the window niche so the client always feels close to the outdoors. *Below:* The flip side of the primary bedroom's box bay window backs up to a secluded oval garden just beyond. *Following spread:* An ethereal palette speaks to the lightness of being that gives this room its distinctive sensibility. The beamed detail animates the truncated vault of the ceiling, adding visual texture and character.

Opposite: A Murano glass chandelier anchors the center of the primary bath with a controlled explosion of floating effervescence. Set into a niche designed for the purpose, the tub overlooks the creek that runs through the property. Sheer panels do double duty along the window walls by softly filtering the light while also establishing the desired privacy. *Right:* In this primary bedroom, the antique Italian mirror inserts an inviting flourish of history, patina, and ornament. Like a grace note, it hovers above a contemporary dresser with drawer pulls that, in the shape of butterflies, nod to the client's love of nature, and the exterior always in view. *Below:* A ladylike skirted chair pulls up to the built-in makeup vanity where ample mirrors and a handy sink offer convenience. A tall cabinet provides ample storage in conjunction with the vanity drawers. A bead detail understatedly defines all the storage elements. A wire-brushed finish on the Douglas fir panels adds another quiet, soft, subtle layer of complexity to the serene visual mix.

Above: The glassed-in stair tower anchors the opposite end of the house from the primary bedroom and frames a switchback staircase that wends its way through the interior from the basement to the second floor. The verticality of this active transition space presented the opportunity for design invention in the form of a custom chandelier created with a contained tempest of handblown falling glass leaves that, in the most ethereal way, brings the outside inside. *Left:* A local artisan handcrafted the stair rails and banister to our specifications in blackened steel. This material choice harmonizes with the mullions and muntins of the windows, resonates with the underlying geometry, balance, and structural logic of the house's architecture, and echoes the pervasive spirit of lightness in the living spaces. *Opposite:* Stair landings often offer an opportunity for art. Here, a switchback between the first and second floors furnishes just the right moment for honoring the client's passion for all things equestrian with a bronze horse head on a custom plinth taking pride of place.

Opposite: A bridge connects the stair tower to the central bedroom hall on the second floor, a pragmatic use of the transverse space created by the pair of gables on either side of the house. Skylights process down the hallway, ensuring that an abundance of light can spill naturally into this central axial core with the help of windows at either end. *Above and right:* Each guest bedroom has its own palette and personality. This one tends to the more obviously masculine with dark hues, distinctive textures, and the rack of the stag commanding the bed wall beneath the gable. The glass globe fixture echoes the fenestration details used throughout the house. Opposite the foot of the bed, a comfortable chair and side table create a place for reading and conversation. For visual consistency, the grid of artworks echoes the grid of the fenestration just adjacent. *Following spread:* In another guest bedroom, antiques meld with vintage pieces and more artwork. The installation of Claire Crowe's butterflies animating the bed wall is a variation on this recurring motif.

Left: From its axial placement, cedar-shake roof, white-painted wood, and brick components, the carriage house, which doubles as a party barn, keeps faith with the rest of this project's formal architectural thinking and disciplined yet expressive material language. *Below:* In this guest bedroom, parchment panels sheathing the walls give the space a quiet luminosity. The custom headboard surrounds the head of the bed in a close (but not too close) structural embrace; the dimensions are generous enough to allow for pairs of side tables with lamps. *Opposite:* The pool house incorporates an outdoor pool cabana with a pair of flanking baths tucked under the porch and outdoor showers around each side. *Following spread:* The back of the house unfolds on axis from the pool house directly across the pool pavilion; the view is like a laser straight through the interior of the house to the landscape beyond. The small structure to the right is the carriage house/party barn; the gabled form behind it, the stair tower; the corresponding gable at the far left, the primary bedroom.

Art and Industry

When Shakespeare wrote "what's past is prologue," it seems unlikely he was thinking about design and architecture. But what if he was? Much more goes into the tooling and fine-tuning of a home than meets the eye, which is why a grasp of the backstory can be so illuminating. These clients were deeply rooted in a comparatively traditional house in the Morningside neighborhood of Atlanta when they decided to build a contemporary home. As soon as a property they had been eyeing across the street became available, they began working with my architecture partner Bobby McAlpine. The two-story courtyard house they created carries cues of classic, twentieth-century modern design in its crisp, geometric forms, well-windowed ground floor, and band of windows that wraps the upper story. The C-shaped layout embraces a pool in front, a walled garden in the back, and a footprint that affords views into the courtyard from almost all the rooms, including the living room, dining room, den, kitchen, and primary suite on the ground floor, and two guest bedrooms and their baths upstairs.

When clients are collectors, their aesthetic passions inevitably inform our design choices to the last detail. This couple shares an eye for photorealistic paintings of industrial subjects. These works, many of which are very large, gave us strong cues about what they would be responsive to design- and style-wise, as well as ideas about how to play to those notes.

We all agreed that a backdrop of neutral tones would be the clear choice to set off the artwork. We talked through general ideas about art placement as we were planning the layout of the rooms, then pulled in forms, patterns, textures, and touches of color from the artworks as appropriate for the decoration. The collection also influenced the selections of accessories to further the story.

They had leaned into traditional and transitional decor in their former house, but many of their existing furnishings unexpectedly tended to the contemporary. After culling their holdings, we transplanted about a quarter of their pieces to seed the new mix with some personal history and memories.

Their living and dining rooms live in air and light thanks to the expansive windows. The living room has an interesting asymmetry that mandated the location of its two seating areas, one in the window, the other by the stair. When these clients are entertaining, they can gather a small group comfortably in either, while the overall arrangement accommodates a large group.

The study offers the homeowners a dark retreat when the urge to read, watch a movie, or just relax strikes. Hand-troweled plaster walls burnished to a soft reflectivity embrace the space in visual silence, and deep upholstery beckons.

A chalky limewash paint that does a slow dance in the shifting light brings character to the walls of the primary bedroom and sets the stage for the furnishings. To make sure this bedroom felt more intimate than the others, the fabrics and finishes skew a few shades darker than the palette in most of the other rooms.

Their kitchen is a place of both art and industry. To tie in the industrial motif, we created oversize images honoring the inspiration of 1930s-era WPA murals to cover the upper cabinet fronts and transform the usually utilitarian panels into so much more. The spirit of the clients' art collection is made manifest here through design. This house is a well-tooled machine for living, both beautiful and beautifully efficient.

Page 51: For these clients who entertain regularly, an oversize, wall-spanning fireplace focuses the living room's balanced but unmatched seating areas, which adapt easily for small and large groups. The lustrous silvered glass mirror inserts an art deco–inspired flourish that suits the clients' various collections. *Opposite, above, and right:* A pivoting steel-and-glass door system opens off the entry courtyard, inviting visitors into the hallway vestibule leading to the living spaces. Suspended from the ceiling, a custom steel-and-wood console replaced the typical console or entry table. This unexpected solution, which felt appropriate because of the clients' love of industrial design and the machine-age aesthetic, provides a sympathetic baseline for Roland Kulla's artwork and sets the scene for what's to come. *Following spread:* At the kitchen island, various seating options address different postures. A WPA-inspired mural covers the upper cabinets with a bounty of art, while the reeded detail on the below-counter storage plays quietly to the architectural forms.

Left, below, and opposite: Sandblasting the limestone of the fireplace surround provided an understated yet practical way of adding in another layer of texture to the rich and varied tactile medley of the living room. The mottled but nevertheless serene carpet gave rise to this room's tightly controlled color palette, including the hues of the velvet used on the pillows; this careful decision-making process allowed the clients' artworks, like the Roland Kulla piece above the sofa, to become the living room's main visual event without overwhelming the atmosphere of luxurious restraint that was the overriding goal for this room. A sofa nested against a window, like the example perched between the curtain panels here, pragmatically redefines fitting options for the term *window seat*. The cast-iron finials in a range of sizes—vintage remnants of a structure no longer extant—were a fortunate find in Atlanta, and just right as accessories for these clients who have a passion for the art, architecture, and design of the mid-twentieth century's robust industrialized machine age.

Opposite: The primary bedroom, on axis with the den, overlooks the entry courtyard with the pool at its core. Both the primary bedroom and the den walk out directly to this verdant green space, a lovely private oasis that inserts nature's colors into the black, white, and gray tones that prevail within the interiors. *Above:* In the den, the tonal palette swerves to a more saturated set of hues for contrast with the rest of the interiors and because the clients often repair to this space for television viewing and/or as a nighttime retreat. Heightened pattern and texture here also warm up the room's atmosphere. The artwork is by Steve Penley. *Right:* The dining area, which opens off the entry vestibule hallway, plays with the balance and contrast of curves and angles in every aspect of its decor. The chairs were brought along from the clients' previous residence, while the table is a new piece selected specifically for this space. The custom lantern not only echoes the dialogue of the geometries but speaks to the steel framework of the glass window wall and French doors.

Above, left, and opposite: The limewash paint blanketing the envelope of the primary bedroom brings with it the added benefit of a considerable amount of movement, patina, and character, which energizes the space for living within. The color and texture of this paint finish change as the light evolves over the course of the day and evening, quietly activating the large expanses of wall space. Floor-to-ceiling curtain panels in a matching hue ring the room with a softer architecture, framing the windows on three walls and extending from wall to wall behind the bed. The silk-and-wool rug lays a foundation of luster and organic pattern that makes for an interesting surprise as well as a counterbalance to this room's plethora of solid surfaces. There is something particularly inviting about a seating area just opposite the foot of a bed for lounging, reading, and chatting. A console and commode placed in proximity to a window provides a large surface for lighting and accessories, as well as functional storage, without blocking the view; this design from my collection echoes the reeded motif that recurs throughout the interior.

Opposite: The study's saturated charcoal wall covering sets the stage for the most pronounced use of color and pattern in this home and creates a wonderful backdrop for the clients' various collections, including the artwork by Thomas Darnell above the sofa. *Above:* The powder room makes the most of the lush garden view. *Right:* The spa-like primary bath is tranquility made manifest. The bathtub sits centrally in a niche created just for the purpose of contemplating the view of a private walled garden, while a pair of vanities bring function and form to the flanking walls. *Following spread:* Given its courtyard configuration, this house has an unusual, rather leisurely procession from the street-facing front wall through a gate into the courtyard past the pool to this loggia. Given Atlanta's clement climate for much of the year, it made great sense to furnish the loggia for dining as well as lounging to extend the living and entertaining areas into the outdoors, while making the most of the fact that this space also serves as the primary point of entry to the interior.

The Landscape of Home

Everything comes from somewhere. Truly new ideas are as rare under the sun in architecture and interior design as they are in most human endeavors. Our aim always is to find new aesthetic expressions for the client and the context. This Palm Beach house, which we conceived from start to finish, is one example of that quest. These longtime clients purchased this lush property on Lake Worth after we had gut renovated another residence nearby. Their dream—and mine for them—was a house with pretty, clean, contemporary lines and crisp, easy-to-maintain interiors. Given this coastal region's intense climate conditions, we knew we would be working with a strict architectural language of stucco, concrete, and roof tiles. We also felt that a comparatively straightforward decorative approach made sense because this was a secondary home.

From the get-go, the clients made it clear that, above all, they wanted to feel a sense of place, to be able to walk out and experience the luxuriant tropical surroundings. For us, this meant rooting the landscape solidly into the sight lines and connecting each interior space to those adjacent and to the exterior. The see-through-the-house plan we devised put the front entry on axis with a double-height main salon and the pool and Lake Worth beyond, so the moment of welcome comes with the gift of a magnificent view.

The entry gallery, which supports a floating bridge-like mezzanine overhead, establishes the transverse axis. At each end, windows overlook lush green perimeter walls that meld the ornament of architecture with the layering of nature. The two asymmetrical wings that extend off the main salon house guest bedrooms and a snug library/den in one, and, in the other a dining room, a kitchen intended for congregating, and an adjacent breakfast area that walks out to a loggia supporting the outdoor living room opening off the upstairs primary suite.

The homeowners asked for interiors that were contemporary in look, and warm in their embrace. As a rule, I seek out natural notes to bring character to large surfaces, especially ceilings and floors. Here, this led us to incorporate lots of wood in different expressions underfoot and overhead, everything from planks to beams to coffers.

These clients appreciate antiques, so we knew to hunt for some special Continental gestures with age and patina. These enrich the mix of comfortable, clean-lined furnishings and favorite pieces we have carried through their homes over the years. Because these clients are avid art collectors and love to rotate works in and out of their homes, we opted for a quiet tonal palette that allows for flexibility and feels right for them and this sun-drenched place.

For me, using the power of contrast is a means of attending to the various emotions that every home must support. This plays out here in the bright, airy, open spaces we shaped for entertaining and in the one dark, saturated room—the library/den—that we inserted for these clients to sequester themselves away at the end of the day to watch a movie or simply relax. We leaned into practical, pleasing-to-the-touch, indoor/outdoor-rated fabrics to dress all the upholstery, and delighted in the play of accessories like Fortuny pillows and intricately embroidered throws to layer in character and age.

Every aspect of this house was born out of the doing. The grand idea, such as it was, hewed to the tried and true: to filter each choice through the lens of the person, the place, and the desired aesthetic.

Page 67: From conception to completion, the architecture and decoration of this house focused on celebrating the magnificent site, lush landscape, and seamless indoor/outdoor living, as well as the clients' love of Italian and Continental antiques mixed with modern furnishings and contemporary art. The concrete-and-stucco construction ensures resilience in Palm Beach's very beautiful but occasionally tricky climate. Right at the point of arrival, a gracious entry court welcomes visitors with a vista straight through the house to Lake Worth beyond. *Opposite, above, and right:* Floor-to-ceiling windows at either end of the entry hall play a considerable role in defining this interior's sense of place by connecting it directly into a lush landscape of plantings and architectural artifacts at the moment of transition from outside to inside. The beamed ceiling layers a plane of interest, texture, and scale overhead while infusing the space with warmth. An open-tread stair does a wonderful job of traversing the two floors while maintaining open views and the flow of natural light.

Above, left, and opposite: The interior architecture sequences the living spaces without enclosing them entirely, a design approach meant to establish gracious, comfortable parameters for distinct areas dedicated to the various functions of living while at the same time focusing sight lines to the surrounding gardens. An intimate conversation group in the great room off the entry hall cozies up to a central fireplace in a freestanding wall that simultaneously divides and connects the living and dining areas while shaping views deep into the interiors and out to the landscape. The mezzanine bridge above the entry hall looks across the great room to the pool and Lake Worth beyond. As interested in modern design as these clients are, they take equal delight in antiques, especially all things Italian, like the pair of nineteenth-century Italian chandeliers at the heart of the great room's lofty volume. Such pieces with patina meld with the vintage and contemporary furnishings and the clients' artwork to create rich layers with the warmth characteristic of rooms collected over time.

Opposite, above, and right: The wide wood planks of the dining room's ceiling and floor, set in opposite directions, do much to create this room's atmosphere of warmth and invitation. A contemporary chandelier of Murano glass anchors the space above a simple but elegant table selected for its monolithic form, but also because it harmonizes organically with the room's wood-plank elements. The legs of the upholstered dining chairs slip yet another wood tone into the mix. An artwork by Elliott Puckette commands one wall; the antique trestle table just beneath layers in a rich patina that comes alive in the dappled light from the adjacent garden. Purchased in Morocco, the rug is a favorite from a former residence. A custom limestone server on the opposite wall likewise provides function and form, not to mention another ingredient to this room's menu of materials; the pair of alabaster table lamps do the same as they further the stone story. The grid of artist's sketches bought by the client in Europe provides an interesting call-and-response to its counterpart across the room.

Preceding spread: Designed and outfitted for an avid cook and filled with natural light from windows on three sides, this kitchen flows naturally into the casual dining area. The veining of the quartzite backsplash and countertops animates the space's otherwise solid surfaces. *Opposite:* In the casual dining area and elsewhere throughout the house, window walls retract into the side wall to create a seamless connection for indoor/outdoor living. The plank table here speaks to the plank table of the dining room in a clearly related but still distinctive vocabulary all its own. Gauzy linen sheers soften the architecture and, when closed, filter the light ethereally. *Above and below:* The loggia extends the footprint of this house to the furthest point in the landscape. With areas for casual dining and comfortable lounging and conversation, this blissfully covered exterior space provides necessary shade from the sun, lovely cross breezes, and captivating views of Lake Worth and downtown Palm Beach in the distance. In the rear corner, a wet bar is another convenient enhancement.

Above: Seen from the mezzanine on high, the view extends to the pool and beyond, bringing the outside inside. The great room's main seating group floats naturally on an island created by the area rug. The stone floor extends into the outdoors, blurring the line between the interior and exterior. *Left:* Colorful textiles collected by the clients on their travels bring layers of character and personality to this guest bedroom with an array of patterns and textures. *Opposite:* The wood-plank treatment reaches its high point in the windowed mezzanine over the transverse axis of the central entry, which allows light to flow through the interior from one side to another without impediment. The form of its ceiling takes cues from the angle of the roofline. A pair of slipper chairs flank an Italian antique demilune, creating a place for respite in the passageway and making reference to details of the furniture forms in the ground-floor spaces, specifically the table in the casual dining area. An artwork by Murat Pulat creates a statement at one end of this passageway.

Opposite, above, and right: Like many of the other areas of the house, this primary bedroom opens directly to an inviting, gracefully furnished exterior space—in this case, the clients' own private terrace over the loggia. The bedroom's painted plank ceiling and walls create a light, luminous envelope that wraps the room with quiet interest, understated texture, and warmth. The furnishings incorporate several of the clients' favorite existing pieces from the various other homes we have designed and decorated together over the years. The Asian sideboard, for example, has added its style, function, and patina to every one of our projects since the very first. The regal period French armchair fits perfectly with the writing table positioned just so to catch the breeze. Strategically placed blue accents, inspired by the view of the lake, add grace notes of color like contrasting focal points into the overall palette of neutrals. Tone on tone curtain panels hang dimensionally, almost like architectural fluting, from a blackened steel rod that adds a line of definition on high.

Left: A floor-to-ceiling window at each end of the entry's transverse axis extends the interior view into the lush tropical foliage of the densely planted spaces just beyond the house's exterior perimeter wall. Overscale urns serve as punctuation points to underscore these moments where the home meets the garden. *Below:* The upstairs lounge at the back of the house, positioned to catch the golden hours of both the sunrise and sunset, has become a treasured retreat where the clients start and end the day. *Opposite:* In architecture, interiors, and gardens, symmetry and balance often play a significant role in creating visual and physical comfort. The two giant palms flanking the pool provide a fine example of this principle in the way they frame a strong vista along one of the axes implemented to organize this house's interior and the exterior spaces. Fernando Wong was the landscape designer. *Following spread:* Every design decision here was filtered through the lens of whether it would integrate the house into the landscape and open its living spaces to the surroundings.

Into the Light

Sometimes, a site sings its secrets into every nuance of the design process—and that is exactly what happened here. Our London-based clients with four young children wanted to stake a claim to the California dream by building a romantic, nurturing house, a place with its own point of view and emotional posture. The spot they found is an idyllic span of hillside land near a protected stretch of the Santa Monica Mountains that looks over Will Rogers State Historic Park to the ocean beyond. This gave my partner Bobby McAlpine a rich palette to paint on architecturally, and me and my team endless inspiration for the interiors.

The wife's European experiences and affinity for design gave her a distinct perspective, honed opinions, and an interest in the new, which happily enhanced our collaboration. The house featuring steel windows set in an almost English-feeling slathered stone also influenced our process. We continually questioned how best to create a balance of elements akin to the architectural aesthetic without being literal, and where could we find the most impactful opportunities to divert from it. We played throughout to the gravitational pull of the clients' English influences, love of modern things, and desire for a warm, friendly family nest.

Every great find influenced the next decision. We settled on a humble palette of materials, with woven sisal for the main living room rug, as well as linens, light wool crepes, and other very soft, natural textiles. For the furnishings, we assembled a collection of Continental antiques, patinated reproduction pieces, and upholstery with English proportions. Our very first purchase, and one of the initial items visible on entry, was the stone-topped, carved oak center hall table; its light palette and approachable spirit established the tone for what was to come. The clients also collected some eye-catching art, much of it chosen for specific locations.

Two wings open off the entry hall. One houses the service-oriented spaces; the other, the public spaces, flowing from entry to dining room, dining loggia, main living room, family room, and kitchen. These connected rooms all look out to the magnificent vista or the grove of stunning old olive trees planted by landscape architect Christine London, which specifically inspired the kitchen's array of teals, oranges, and sage greens.

The living room features a capacious box bay window on either side. Not wanting to shroud these windows, but needing the softness of material, we draped them diagonally, which created a dynamic spatial tension. Sofas sculpted to take advantage of the views sit in the bays; a third sofa near the passage to the dining room finishes that circle. The dining room makes the most of the drama of the valley view; the inviting contemporary table welcomes a selection of antique dining chairs alongside slipcovered armchairs for comfort and personality. A comfortable lounging sofa big enough for the whole family to pile up on beckons in the family room.

The second floor is the private family zone. The second-floor landing opens to a small library for the kids. The primary suite, basking in the endless panorama, nests under the gables on one side; the kids' bright en-suite bedrooms are arrayed along the other, plus a rec room carries up pops of color from downstairs. This is California dreaming made manifest—a dream for this family to live in every day.

Page 87: In the entry stair hall, the tones of the gridded limestone floor lay the foundation for this space's quiet palette. The sweeping drape of the tapestry by El Anatsui picks up on the grid motif and, serendipitously, the color palette. *Opposite:* The center hall table, the first piece purchased, introduces the English and Continental references and handcrafted refinement so essential to the aesthetic of these interiors. *Above:* Concealed doors in the entry hall reveal the front powder room. *Right:* Scale and pattern come into play in the harmonious call-and-response between the details of the architectural paneling and the floor; even the lantern picks up on their repeated geometries. The painting is by Günther Förg. *Following spread:* An overscale globe lantern, which echoes the steel fenestration of the box bay windows in its details, anchors the central salon. Natural wood ceiling beams, sisal flooring, and English-inspired furnishings, including a pair of modern wing chairs by the fireplace, contribute significantly to the room's timeless air of casual elegance.

Left, below, and opposite: When the challenge is to furnish a capacious room to function seamlessly for gatherings of different sizes, both large and small, there is nothing more welcome than a niche in which to establish an intimate grouping as a retreat for private moments. In the main salon, the pair of recesses presented by the opposing box bay windows provided the opportunity to do that not just once, but twice, all while celebrating the spectacular views. For visual interest, the pieces selected for each seating area relate to those opposite, rather than mirroring them directly. In the box bay overlooking the courtyard, the English library influence is strong. In its counterpart, the English inspiration continues, although with sleeker, leggier forms so as not to obstruct the captivating vista of the pool and the magnificent landscape beyond.
Following spread: Yet another seating area anchors the open end of the main salon. This sofa and coffee table in essence establish a "fourth wall" to define the perimeter between this living space and the adjacent dining area.

Opposite: Context inevitably factors into the design decision making process, especially when the surrounding environment is as marvelous as here. With a floor of reclaimed oak layering in character and history and a double island finished in a dusty green, the kitchen borrows elements of its palette from the hundred-year-old olive trees just outside the windows. *Right:* The furnishings in the neighboring breakfast/casual dining area pull from the same sources to enhance the visual connection between the interior and exterior landscapes. *Below:* The clients and the design team together selected the slab of Calacatta Viola marble on the stove wall specifically for its bold graphic pattern. *Following spread:* The mix of seating styles at the dining table and the box-shade chandelier introduce necessary touches of the unexpected, albeit in a very understated way. Stone-and-steel demilune servers, and the vintage lamps they support, pick up on the materials and fenestration details of the neighboring window wall with inset French doors that open to a loggia just beyond.

Preceding spread: The entry hall introduces the personality of relaxed refinement pervasive to all the living spaces within and around this home. The clients purchased the tapestry by El Anatsui, which found its perfect home hanging in the entry stair hall; as much of a stand-out piece as this artwork is, it also suits these surroundings so organically it could almost have been made just for this space. The custom lantern lifts the details and materials of the window wall and custom balustrade into the lofty core of the entry hall, tying the space together. *Left:* An antique Spanish table topped by parachute lamps inserts flourishes of history and whimsy into the family room. *Below:* In a play on life's essential four elements, a console designed to store firewood for the outdoor fireplace beneath an overscale, two-tier farmhouse chandelier centers this view to the comfortably furnished pool cabana. *Opposite:* This area of the den beyond the kitchen incorporates a seating group intended for movie watching; the colors, clearly, come from the lush foliage of the adjacent courtyard garden.

Preceding spread: Totemic forms, essential furniture pieces, oversize upholstery for casual lounging and conversation, and stalwart natural materials like basalt and thatch carry the aesthetic of rusticated refinement from the interiors into the exterior rooms and endow the pool cabana with an air of timelessness supremely suited to the mountainside setting. *Opposite:* Bathed in a mysterious shade of deep, dark green heightened with piquant tones of blue pulled from the sky and the Pacific Ocean nearby, the library stands as a deeply moody but serene retreat and provides a necessary and welcome contrast to the home's overall lightness of being. The abstract painting by Andreas Eriksson somehow speaks to this essential balance in the decoration. *Above:* Velvet-covered contemporary wing chairs—an updated take on a traditional form echoed elsewhere in the house and just right for this library setting—anchor a seating area that flanks the fireplace. *Right:* The library walks out to its own private garden, one of the main inspirations for the choice of the palette within.

Preceding spread: Soft tones of lilac and sage green borrowed from the seasonal hillside blooms breathe whispers of color into the very muted palette of the primary bedroom. The canopy bed provides an inviting nest within the expansive volume of this space where pleasingly plush textures offer sensory delight in all directions. The artwork above the fireplace is by Aythamy Armas. *Opposite:* In one daughter's bedroom, floral wall covering incorporating shades of her favorite dusky lilac wraps the walls to create a private oasis of a garden. As an alternative to the standard bunk or trundle bed, when possible, built-in side-by-side berths for sleepovers serve their function beautifully. The dimensional carpet adds another layer of pattern and texture for visual and tactile interest but in the subtlest way possible. *Right:* In the other daughter's bedroom, a draped canopy bed takes pride of place—a young lady's regal retreat. *Below:* The children's playroom comes to life with strategically inserted pops of color in the sofa, wall covering, and, of course, the toys.

Above: The light-filled guesthouse bath has a serene, spa-like feel akin to the prevailing aesthetic of this property's interiors. *Left:* A powder room off the family entry to the main house continues the thematic design device of bringing the outdoors into the interior, here with a vine-filled floral wallpaper rich in birdlife, too. *Opposite:* In the primary bath, an antique campaign chandelier descends above the bathtub, a sparkling statement piece that, with its faceted crystals, induces light to dance around the room. *Following spread:* The guesthouse across the central courtyard offers guests physical separation while remaining visually connected to the main house. A welcoming seating area by the window invites contemplation of the garden view. Gauzy linen sheers adjust for privacy. *Pages 116–17:* The grove of ancient olive trees just beyond the kitchen creates a natural canopy over an outdoor dining area; lights drape from tree to tree to enhance the usability of this space once night falls. The landscape architecture and garden design are by Christine London.

Places of the Heart

In every home I design, my goal, always, is to create a through line of meaning. This is no less true for the properties that my husband, John, and I have built together. From our first New York apartment to this house in Provincetown, our second home built from the foundations up together, we have aimed to instill our surroundings with personal resonance. For us, that has involved tethering the elements of design to the specific location, emotion, or memories that have given each dwelling its birth.

John is from Massachusetts, and had a long, rich, and somewhat melancholy history with Provincetown before he and I met. This magical tip of Cape Cod held many unreconciled memories from his youth, so it had been years since he had set foot here when a friend invited us up for a milestone birthday celebration. Returning here as a couple, we both saw this remarkable place again with fresh eyes. A vision of what living here might offer us both began to take shape, and we started toying around with the idea of owning property in Provincetown. Initially, we agreed to renovate because we had only just finished building our Nashville home. After my critical architect's eye found some reason to say no to everything we saw, though, our thinking shifted to building. John's one proviso? That we find a lot right in town.

The property we found was deceptive at first sight, but as it turned out, it was our own Sleeping Beauty. When we first happened onto it, a foreboding thicket of woods and briars blocked entry from the street. Then Google Earth revealed not only another means of access, but that the plot itself was a marvel: home to an old-growth forest, abutting protected wetlands, with a swell populated by enormous ferns, and a berm perfect for landing a house. We biked back to take another look at the "golden hour." And we found Valhalla, with sunlight filtering in horizontally underneath the trees and glancing off the giant fern fronds. The gnomes and fairies were palpable. The search was done.

Our tiny little spit of land right in the heart of town abuts the protected wetlands, giving us unusual privacy in this old New England fishing village where houses butt up right next to each other. It is also just a ten-minute bike ride to the beach, heaven for beach lovers like us who also delight in the cool darkness of the forest at night.

Figuring out what kind of house would be respectful and appropriate, but also different enough in tone from the neighbors to be interesting, presented a fascinating challenge. A mandated setback kept the foundations to a specific position, with an L-shaped footprint to fit around the wetlands. Neighborhood restrictions imposed a strict height allowance. The deep overhangs that shed rain away from the house, common in Southern vernacular architecture though very unusual in Provincetown, would allow us to worry less about leaving all the windows open at night. Because we were on the edge of the wooded wetlands, a house that would fall into the shadows felt right, which inspired the black exterior stain.

To make the most of our compact 2,500 square feet of living space, including the deck and screened porches, I wanted to maximize the end of day experience and did not want us living on the ground floor. This led to zoning the house in layers, with our own private Idaho at the top; a guest room and my office, each with its own screened porch (perfect for sleeping), on the entry level; and the main living area in the middle on what the Italians call the piano nobile.

Given just two and a half stories, I kept the ground floor spaces quite compressed under 7 ½-foot-high beamed ceilings. Arrival really occurs up the open corner stair on the second level, where the ceiling height expands up to 10 feet. Here, window walls and corner windows gain a view to the forest. I anchored the living and dining areas on axis with a substantial stone fireplace and banked a sofa against the big run of windows to center the living space. The other leg of the "L" hosts a small powder room and an open kitchen that unfolds to a screened porch with a small outdoor dining table and lounge seating where we spend most of our time. There is also an invitingly big deck off the back. Another flight rises to the gabled spaces with our primary bedroom and bath, and a sitting room, all tucked under the eaves.

I wanted the interiors to hark back to shipbuilding, and for the experience of each level to be distinct. From stem to stern, from top to bottom, the environment of Cape Cod Bay gave us cues for color palette and materials. In the public areas, vertical planking and a combination of neutrals and deep Bay blues set the scene; here the carpet is striated with an almost wavy quality. The kitchen skews more beach forest in coloration with greens, blues, and dark cabinetry. The primary bedroom captures the spirit of the walk to the beach through the marsh grass that inspired the color palette.

This house is the place of ours that John loves most these days. I always knew he would have a special relationship with it, as I do with our Nashville house, because it is close to his family, taps into his past life, and recasts that story and its memories in a new, very positive light.

Page 119: The architecture integrates New England's indigenous forms with functional Southern vernacular, both filtered through a modern lens. With black stained planks, the facade melds into the woods; the white-painted windows provide definition. The front door is lacquered in a blue inspired by the bay. *Preceding spread:* The entry's white-painted wood walls, stone floor, contemporary chest, and artwork by Stephen Keeney flip the switch on the exterior. A screened sleeping porch opens beyond. *Left and right:* The living area one flight up centers on a fireplace wall of local stone with a custom steel ledge for candles and accessories, as well as a mirror to reflect light around the room. The palette of blues corresponds to the context of the Cape. The overhanging eaves, another Southern architectural detail, divert rain, so the upper sashes can stay open all summer long. *Above and following spread:* The dining area flows off the living area and into the kitchen. A combination of contemporary pieces, vintage designs, and antiques brings a collected sensibility to the decor.

Above: A natural wood end table brings unexpected texture, a rugged rawness, and a convenient surface for lamps, drinks, and the occasional book or newspaper to the breakfast area adjacent to the kitchen. *Left:* The durable quartzite of the countertops and the island with its waterfall edge folds an enlivening breath of pattern into the combination of overwhelmingly plain and solid surfaces. *Right:* The porch extending off the kitchen is somewhat modest in its dimensions, but still expansive enough to hold outdoor dining and lounge areas; it's also a fantastic place to savor the golden hour with friends. *Following spread:* The dining area is positioned as a gracious welcome at the landing of the first flight of stairs. To ensure that the surrounding views are always as accessible, and to allow as much of the Cape's magical daylight as possible to flow into these living spaces every day, the dining table base as well as the dining chairs feature comparatively open frameworks. The stair treads are also open for the same reason. The second flight leads up to the primary suite.

Preceding spread: With a custom daybed that could not be more comfortable, the sleeping porch off the entry is a favorite place for a nap or reading on a rainy day. *Above:* The primary bath on the third floor lives right under the eaves. The vanity houses a pair of sinks and ample storage. Twin custom pivoting mirrors above make shaving a breeze. *Left:* Set into a marble and wood surround, the tub in the master bath is positioned perfectly to overlook the woodlands that abut the rear of the property. *Opposite:* The bedroom nests under the eaves, cozy, private, and far removed from the guest rooms on the first floor. The color palette here brings in the hues that highlight the walk to the nearby beach. Portieres, usually left open, separate the primary bedroom from the adjacent sitting area, which walks out to another furnished porch for taking in the luxuriousness of the beauty nature presents every day. *Following spread:* The screen porches stacked one atop the other on the second and third floors are part of the interface created here between architecture and the wild.

Enchanting History

There is a kind of delight in navigating daunting design complexity into an organic-feeling outcome, and the learning that comes with it. This historic property in Southampton, New York, which we reimagined for longtime clients, alongside landscape architect Mike Kaiser, into a full family compound with a series of new outbuildings, proved to be both. It also reminded us repeatedly that restrictions are so often the wellspring of invention.

First things first. The main house—a seven-bedroom, Victorian-era grand dame with numerous gables, projecting dormers, bay windows, and a sun-filled, south-facing pillared porch—has long been an architectural fixture within Southampton's historic district. The town's architectural review board was expectedly vigilant in its concerns for the property's history. We tapped our deep reserve of respect and restraint with each exterior intervention and alteration. The porch, one of the property's main draws for our clients, became the key organizing principle of our renovations, inside and out. Our additions, among other things, extended it to connect the newer and existing portions of the home more seamlessly.

Inside, this house was a puzzle box of compartmentalized spaces accrued over time. The ground-floor rooms especially needed shifting, reorganizing, and revising to suit this young family's craving for an easy, relaxed flow; axial vistas; and an abundance of light. In one major move, we carved out an ample pass-through between the original living room and what is now the family room, which is one of the new spaces. We tore off an ungainly attachment at the rear of the house from a prior renovation and replaced it with an expansive two-story addition that completely reorients the life lived within the entire house and creates the kind of organic engagement with the exterior living spaces that all of us crave in the summer. Specifically, this gracious wing, as it were, adds a back entry and stair, a family keeping room, back kitchen pantry, pantry with an appliance closet, capacious kitchen, and glassed-in dining area. Retaining the earlier molding style helped us create echoes of period harmony with the original portions of the house. Now, from the moment of entry, the vistas and views let in the sunshine and unfold invitingly through a gracious sequence of living areas to the back porch and the grounds beyond.

The primary suite, which basks in the dappled light from the property's old-growth trees, commands much of the second floor in one of the newer sections of the house. Also on this floor are one child's bedroom as well as several guest rooms. One more flight up we tucked two more children's bedrooms under the attic eaves.

Putting the furnishings and decoration to work to capture and transcend the house's long history made sense both emotionally and stylistically. To create the multiple layers and dimensions, we combined antiques of various periods with the clean, contemporary furnishings that fit this family like a glove. And to keep the mood interesting, we mixed in a few pieces that happily break the mold of summerhouse expectations.

The outbuildings blend the new with the reinvented as well. The pool cabana is a sweet addition that, for consistency, takes cues from the materials of the main house. The three-bedroom guesthouse, also just built, incorporates a glassed-in living room, cozy kitchen, and guest rooms; this smaller residence echoes the main residence, too, in its beautiful, south-facing porches, which are similar in spirit to those that inspired the clients to buy the original property. Last, but not least, we transplanted an existing barn and transformed it into an entertainment pavilion. Bringing this historic property into the present while honoring the best of its past could not have been a more complex challenge—or a more deeply rewarding one.

137

Page 137: The proportions of the main salon required a procession of multiple pendant fixtures marching down the ceiling's central axis to create a spatial rhythm that speaks to human scale. In the bay window, a custom console can pull away from the drapes to function as a bar for entertaining. The balance of furnishings in this room are new purchases for this residence, including a sofa from my collection. The mirror over the mantel, acquired for our first project together twenty years ago, has graced several of the clients' residences since then. *Opposite:* The French doors by the game table open onto the side porch, a major attraction for the clients and an inspiration for much of the new architecture. *Right:* Given this house's long-lived history, a mix of modern and traditional pieces felt appropriate to setting the scene in the main salon; this blending of periods continues throughout. *Below:* Part of the addition, this final room of the entry enfilade is adjacent to the kitchen; it expands the available space for family seating and increases the flow of light within.

Previous spread: The expansive new addition, which on this level encompasses not only the primary kitchen but also the adjacent pantry, incorporates a raised ceiling height, beams, and coffers as key characteristic features. The primary kitchen is designed for family living yet also envisioned and detailed as a proper room, one presentational enough for entertaining; it is now strategically connected to the interior gathering spaces through the open plan and to the exterior living areas via French doors inset into the wall of windows. *Left and opposite:* The pantry doubles naturally as the family entry. One entire side of this room is given over to storage for linens, platters, and the other useful accoutrements for setting the table for daily use and celebratory events. The marble-topped central table, inspired by Edwin Lutyens's Castle Drogo, serves as a second island. The brass interior of the pendant fixture casts a lovely, warm glow after the sun sets. *Below:* The design of the main island in the primary kitchen took cues from the turned leg of an antique Flemish table.

Opposite: The addition also allowed for the creation of a central stair that traverses all four floors from the lower level to the attic and provides a consolidated vertical connection through this new wing of the house. *Right:* The ground-floor family powder room captures the past-meets-today spirit of this renovation in its combination of light, dark, matte, and shiny. A high-gloss lacquer transforms the walls, while accents of natural oak bring in notes from the outdoors. *Below:* The primary bedroom, which lives on the second floor above the kitchen, offers the perfect perspective to look across the property in several directions. The vertical planking covering its walls layers in a historical reference with an organic feel. The replacement window casings and doors exactly replicate the originals surviving in the house's older areas. *Following spread:* This wraparound corner of the porch with areas for dining and lounging is just one example of the many architectural decisions made to facilitate as seamless as possible a connection between indoor and outdoor living.

Pages 148–49: From a purely architectural standpoint, the extensive wraparound porch addition functions as a major component in the quest to unify the new wing with its existing historic sibling. *Preceding spread:* Paved stone pathways reinforce the axial orientation and organize the landscape of the rear of the property as it unfolds from the back of the main house to the reinvented party/play barn, transplanted from another spot on the property, into the deeper reaches beyond. *Left:* The interior of the play/party barn provides a choreographed place on entry for board games, card games, and puzzles. Pool and foosball tables and shuffleboard draw this family and their friends upstairs to the loft. *Below:* With an overscale sectional backing up to a storage wall with built-in refrigerators, the barn's primary seating area could not be more inviting. *Opposite:* A bracketed copper roof element shades the entry to the barn and sheds rainwater away from it; the barn's French doors sit perfectly aligned on their cross axis with the gate to the pool and the pool deck beyond.

Opposite: The loft under the gables of the party/play barn is filled with light thanks to ample windows on high. *Right:* The lighting fixtures that descend from the peak of the ceiling over the seating area help unify the full two stories of this structure's vertical space. The lounge seating, which can accommodate a goodly group, provides a gathering spot for games and movie watching. *Below:* The heavy timber used to brace the upper reaches of the loft's construction takes cues from the standard barn vernacular, as the barn is an indigenous form, an architectural archetype that represents the agricultural past of Long Island's east end and surrounding areas. *Following spread:* The guesthouse, inspired by the porch addition and various expressive details of the original house, including the columns, roof, and terraces, also incorporates picture windows under the eaves, a fenestration type not found in the main house. Its architecture also celebrates symmetry, while the original house has all the charming quirks of the period and style of its birth.

Preceding spread: Sheer panels can swathe the entire ground floor of the guesthouse in a cocoon of privacy. Like the addition to the main house, the corners here are glassed in so visitors can experience the full breadth of the view. Because the ceiling is the interior's largest surface, it made sense to finish it with painted planks and beams to generate shadow play. The dining area's chandelier echoes the seasonal blooms of the wisteria outside. *Above:* The antique chest stands before the interior portieres like a sentry signaling "welcome to the heart of the house." *Left:* The fenestration details in the entry stairwell literally bring the exterior of the guesthouse inside. *Opposite:* The kitchen's storage shelves hang in front of the windows without obstructing the view. *Following spread:* The living area floats in the center of this glass room under the eaves. *Pages 164–65:* Painted black to make it disappear into the landscape, though with a white pergola that stands out, the pool pavilion encompasses lounge seating, a changing cabana, and a small outdoor kitchen.

Mountain Magic

Sometimes in life, we find that to fulfill our dreams and goals, like building a forever home, we have to transplant ourselves. This was the case for these longtime San Francisco residents, who headed to Utah and commissioned my architecture partners Greg Tankersley and Bobby McAlpine to design their house, which became an interesting study in contrasts. While the stone exterior has a traditional cast, the interior takes on a clear, streamlined, contemporary expression thanks to the steel beams and columns that frame most of the living spaces.

The slope of the hillside property mandated putting the main living spaces one flight up from the entry. These second-floor areas reside under an immense vault of a ceiling plane, which is really a series of vaults created by an origami-like construction of intersecting planes that mark the boundaries in the flow of the open floor plan. From the get-go, we knew we would use the furnishings to populate the lofty volumes and create comfort at human scale.

These clients took a very hands-on approach to their project, diving into the experience of design discovery and delighting in seeing and touching all the elements we would need to complete their interiors, everything from stone slabs to furniture to textiles. As we gathered all sorts of terrific, interesting items on shopping trips with the clients to both coasts, we could see just what they responded to, and also what they really loved. This knowledge transformed our decorating process into a truly fun matter of assigning use and location for all their favorite cherished items.

The living room, butler's pantry, kitchen, and dining room flow organically from one area into the next, so it was important that each space meld with the others while having its own personality. For the living room, we centered the furniture plan around the fireplace. We dressed the butler's pantry in a quartzite that also frames the entry to the kitchen and the kitchen countertops. This richly colored, deeply striated, highly figured stone was a bit outside my team's typical serene sensibility. But when we saw it in a marble yard in Utah, our only question was, "Where can we use it?" These types of discoveries, made with our clients, are always special because the choices feel so much more personal when the clients see these items in their home.

Our preference is to always work within a palette of textures and tones that feels appropriate to the site. This led us to chenilles, linens, and other textiles with visual personality and tactile presence. We drew the black, white, and subtle hues from the Utah hillsides, where the stone has a taupe-y, almost terra-cotta tinge mixed with shades of gray. Inevitably, small shots of color also made an appearance, especially an elusive celadon tint echoing the wild sage in the landscape.

To create the layers needed to make contemporary houses like this one feel rich and nuanced, a family home for forever, we made the most of the contrasts. These rooms of darks and lights, matte and sheen, plain and luxe, and fabrics like chenille all change their appearance throughout the day and night in a quiet, magical way.

Page 167: The vaults and columns of the interior architecture define the boundaries for furniture arrangements within the spatial core of the living area. *Preceding spread:* The tête-à-tête from my furniture line sits beyond the butler's pantry and serves to connect and separate while keeping the view open. The use of patterns is strategic for contrast with the solids. The lantern echoes the shape of the arch from which it descends. *Opposite:* Because this house is built into a hillside, the living areas occupy the space one flight up from the entry, in the manner of the Italian piano nobile. The doors on the left lead to the study. *Right:* The seating group at the top of the landing can serve multiple purposes. These clients have a taste for contemporary design with understated details rooted in tradition, hence the dressmaker details in the upholstery. *Below:* Although the landscape created by the furnishings incorporates a range of forms at various heights, the selections always prioritize keeping the view to the exterior as open and unobstructed as possible.

Preceding spread: The design of the three-legged dining table is one of my own. The marble bases are positioned to allow for the greatest leg room. The beveled edge around the top creates a soft interface, and therefore greater comfort, for those at the table. The bevels of the lantern above pick up on this detail. *Opposite:* The butler's pantry, which leads straight to the kitchen, has counters dressed in a figured quartzite discovered on a shopping trip with the clients. *Right:* The kitchen island aligns axially with the living room fireplace. The top of the island is pewter, which is very durable, casts a very soft glow, and suggests the patina of history. *Below:* In the breakfast area off the kitchen, the two tables meet the symmetry of the architecture and serve dual needs for dining and lounging throughout the day, facilitated by custom banquettes with a split back. *Following spread:* This is the main family room, or den, the place where the family gathers casually. The rustic planks on the ceiling speak to the spirit of the Old West in a very contemporary way.

Opposite: A grass-cloth wall covering swathes the walls of the primary bedroom, bringing with it a subtle texture and the barest hint of color to warm up the architectural envelope. The four-poster bed is a space-defining form in and of itself in the way it creates an intimate area within the room's greater volume. *Above:* This hallway, which leads past the dining area, provides arresting views in two directions: one through the windows to the landscape, the other to the sitting area of the primary bedroom that is its terminus and the mountainside beyond. As always, the goal is to deploy the elements of the interior design, including the window panels, to enhance the experience of living within the architecture. *Right:* The confines of the primary bedroom are generous enough to encompass a seating area at the foot of the bed. The soft, serene blues and grays of the fabrics infuse this area with hues from the outdoors. The low console table offers a handy surface for displaying favorite pieces, including both artwork and a marble sculpture by the wife's father.

Above: An outdoor breezeway connects the working pantry to a guest room. The swivel chairs beckon those making their way through to stop and lounge, while a table and chairs provide another spot for casual dining, one open to the air and, of course, the compelling views. *Left:* A niche in the primary bath offered the ideal spot to place the bathtub to take advantage of the remarkable vista. *Opposite:* This guest room—which is fitted out with all the comforts and practicality of home, including plenty of storage—hews to the subtle quiet palette that washes through the rest of this residence, as well as to the clean, soft lines characteristic of its furniture forms. The room takes on a distinctive personality all its own, however, thanks to the paper patterned with petite falling leaves that covers both the walls and the ceiling. This wall covering, discovered on a shopping trip to San Francisco with the clients, who fell in love with it instantly, became an extra arrow of design held back in the quiver. This room proved to be the perfect place to bring it out and use it.

Reinventing Home

In design, the domino effect so often comes into play in unexpected ways. These clients were already settled in Palm Beach for the winter season when they purchased this house, originally a 1980s, Palladian-inspired mismatch of architectural parts and interior pieces. They wanted to knock away the traditional, to strip down the exterior and interior to a smart, more contemporary aesthetic.

This desire for complete transformation allowed us to pursue our favorite kind of object lesson in editing. How could we dial back what existed to a point where we could reconfigure the entire home to offer proportion, scale, and details that felt more approachable, natural, and organic? We decided, as usual, to begin at the beginning. This meant ripping out the entire arched and gabled front entry portico and removing two extremely ungainly rear loggias. Other than these excisions, we kept to the existing footprint because it allowed us higher ceilings inside than current code would permit.

Putting the house back together involved breaking down large volumes into more intimate spaces suitable to the human scale. We maintained the two-story foyer, for example, and created a small, welcoming entry with a mezzanine overhead, which allowed the architecture to hold people as they enter, then release them into the lofty volume of the foyer. (This intervention had the added benefit of clarifying the jumbled confusion of an upstairs hallway.)

Though the property was right on Lake Worth, the interiors were completely disconnected—really, walled off—from the gorgeous view. To pull back the proverbial drapes and open the vista from the first moment of arrival, we carved out three cased openings beckoning both eyes and feet into the main salon and to the back of the house, where a glass-and-steel door system now folds open at will.

To make the flow of the public rooms more gracious and relaxed, we blew out the side walls of the newly opened central living room with pocket doors that lead into a kind of evening room on one side, and the dining room on the other. This united the house spatially on a horizontal plane, even as it tended to the challenges of the vertical scale.

Because the interior walls were relatively plain and unimaginative, we looked for opportunities to infuse character, interest, warmth, and consistency with organic materials. Beamed and planked ceilings now crown many of the rooms, while a soft gray limestone underfoot in the entry and living room gives way to a wood floor the color of sand in the dining room, evening room, and upstairs.

The kitchen was its own geometry lesson, with an awkward bay window at the very end. By reshaping the window into a generous box bay and gutting the entire kitchen, we restructured it into a very large gathering space for the entire family.

Entry to the primary bedroom is through a series of French doors revealing the view of Lake Worth. We floated the bed in the middle of the room so the clients could revel in the vista. Because there is no reference to the ground, they feel as if they are on a ship, suspended over the water, when they are in residence here—an experience that, like the relaxed comfort of the rest of the rooms, is truly transformative.

Page 183: This renovation began from the outside in, as well as from the inside out, and involved the deletion of a number of large architectural components. The entirely restyled front facade, which previously centered on an overscale Palladian-inspired arch framing its entryway, now welcomes all visitors with well-proportioned geometry and an entry saying "hello" in more intimate, immediate, human-scale terms. *Opposite:* The front stair hall soars once through the door. Wood panels frame the view into the main salon through the newly opened wall on the right. *Above:* A hand-forged iron stair rail and spindles combine with thick stair treads to transform the stair, giving it much greater visual import in the overall scheme. *Right:* In the study off the entry, the addition of paneled walls created warmth and coziness. Centered beneath the spherical pendant, new comfortable chairs surround the clients' Eero Saarinen table to create a place for games, work, and meetings. *Following spread:* The insertion of a glass-paneled folding wall opens the main salon up to the arresting view.

Left: A vintage Biedermeier chest helps infuse these new interiors with patina. The artwork is by Melvin Sokolsky. *Below:* This seating area in the main salon looks to the view in both directions. The Calder-esque fixture overhead is a subtle connector, carrying in the motif of the iron stair rail. *Opposite:* An abaca wall covering wraps the walls of the den off the main salon with warmth and texture. *Following spread:* Contextually inspired light fixtures, like this chandelier echoing a school of fish in motion, add tremendous personality. The water-like wall covering echoes the waterfront. The sideboard from my furniture collection was inspired by a Vienna Secession piece. *Pages 192–93:* The renovation reconfigured the previous kitchen and den into an expansive working kitchen with a breakfast room built into a box bay window opening to the pool cabana. *Pages 194–95:* The breakfast room's indoor/outdoor rug provides durability with style. The curved banquette makes for an inviting place to take in the view. The buoy-like pendant fixtures add a welcome note of whimsy.

Preceding spread: An effervescent glass fixture commands the center of the second-floor primary bedroom without impeding the view. The room swims in shades of soft blues and greens pulled from the water tones. Vintage chairs from Erwin Lambeth pull up to an occasional table with a telescoping 18-inch base that conveniently lifts to 25 inches for dining. The dresser lives neatly beneath a leather-wrapped console perfect for displaying art, photographs, and objects. *Opposite:* The mirrored wall above the marble-topped makeup vanity attends to the usual purposes while also reflecting the water views on the other side of the room. *Above:* The reeded motif, one of several themes established on the first floor, wends its way upstairs and through to the wife's paneled dressing room, where mirrored doors on two sides open the room visually and provide ample reflection for dressing. A custom oval ottoman offers a handy perch for putting on socks and shoes. *Right:* In the primary bath, the figured marble slabs of the floor and wainscot give way to clean white marble tile above. The photograph of the Fab Four is by Harry Benson.

Preceding spread: The newly built pool cabana addition extends gracefully off the kitchen, creating the ultimate convenient outdoor environment for both dining and lounging. *Opposite:* The custom concrete table, which literally anchors the dining loggia, features a completely practical, extremely durable, and very heavy double-pedestal base. The curves and lines of the teak frames of the comfortable dining chairs energize this area through a visual call-and-response with the dining table's distinctive geometries. This loggia is one of a sequence of such covered exterior spaces forming a necklace along the perimeter of the rear facade of the house. *Right and below:* Each of the linked loggias in this added band of exterior architecture is positioned to engage the evolving panorama of distinctive views from the different aspects of the site across Lake Worth and to the city beyond. But even more than that, these loggias ensure that the experience of indoor/outdoor living on this property is entirely organic and effortlessly seamless for the clients, family, and their friends.

Dutch Treat

Time is one arbiter of all things human, including, and maybe especially, designing a home. This Nashville-based family is the perfect exemplar of how time can unexpectedly play an outsize role in the process. These clients were deep in the model-building phase of their long-planned new house with my architecture partners Bobby McAlpine and Greg Tankersley when they realized that their chosen property actually was not right for them. After another search, they found this site in the heart of Belle Meade, and all began again from scratch. This welcoming, wittily detailed Cape Dutch Colonial is the happy result of their deeply analytic and time-consuming process.

These clients hew to a contemporary sensibility, with everything this entails in terms of forms, color palettes, materials, and textures. Entry proceeds past a wall of steel and glass, through a door lacquered a radiant dark blue to offer a punch of color, and into the grace of the columned grand salon, which embraces the living and dining areas between bookending walls paneled with a clear, strong grid. This up-to-date twist on the classic millwork style brings with it visual texture and a hint of age and tradition, plus the perfect opportunity to do something as special as a high-gloss lacquer finish to percolate the palette and to add some reflection. The extra-wide fireplace anchoring one of these walls centers the living area's seating groups. The substantial piece of commissioned art focusing the other gave us elements of coloration that we carried through in the fabrics that dress the upholstery. The adjacent dining area has a relaxed formality inviting everyday use for family meals as well as occasions with extended family and friends. For more intimate moments and meals, we backed up an extra-long banquette, a couple of lounge chairs, and a small table into a niche in the gallery that overlooks the pool. This wing terminates in the lady of the house's office, a luminescent beautiful glass box of a space.

Because these clients were not interested in antiques, or in bringing along any former furnishings, every single solitary piece in this interior is new. We looked to textures like mohair and linen to layer in character and used the gestures of refined, pale neutrals—warm ashy grays, light shades of marble, and saturated creams—to establish a distinctive aesthetic.

The clients entertain almost nonstop and wanted a very large kitchen with two islands to accommodate all sorts of situations, and of course for gathering. The working island alone is large enough to dance on. The second island incorporates banquette seating, making it perfect for a relaxed back-and-forth with anyone in the adjacent family room.

The gentleman's study we swathed in a rich, deep, saturated blue. He has a desk, of course. The plush sofas and chairs ensure that he can lounge as he takes phone calls or meetings—and that the room can convert easily to a television room in the evening.

The primary bedroom, ethereal and visually still in shades of almost-not-there-but-there stone and gray, is the ultimate intimate space. A seating area overlooking the pool beckons on one end, while a fireplace works like a force of gravity on another. The baths we edited to a sophisticated simplicity, but with a slight, icy blue wool drapery that very much complements the clients' coloration. Time and time again, our projects remind us that to create just the right home, the process is so worth the time.

Page 205: Lacquered paneled flanking walls bring an air of formality and tradition to the central receiving/living area, which the beamed ceiling relaxes to a degree. *Opposite:* Custom steel-and-marble firewood holders bracket the pivoting front door, adding texture, warmth, and a touch of the unexpected to the entry; they also provide convenient surfaces for lighting, accessories, and the botanical arrangements that connect the interior to the outside world. *Right:* The colonnade frames both sides of the living area, directing the eye toward the spaces at the back of the house, which include the wife's study at the top of the stairs. *Below:* Rusticated stone lamps with fabric shades stand as sentries by the front door, inviting entry with a welcoming glow. *Following spread:* The wide central aisle dividing the living and dining areas designs in the flexibility to rearrange the furnishings for large-scale entertaining. A custom, low-backed sofa nested into the window provides a necessary punctuation point for the eye as it travels through the interior to the gardens beyond.

Left: The repetition of a design motif at various scales and in different forms and materials tends to please the eye even when the repetition is not glaringly obvious. Here, in orchestrated harmony, the crescent cuts in the lamp base meet the curves of the mounted stone discs nearby, the arc of the top of the occasional table, and the gentle sweep of the neighboring chairback. *Below:* A fireplace in a paneled wall is a classic design solution for instilling a space with the essential idea and emotions of home; here, the extra width of the fireplace and restrained architectural detail of the mantel is a major aid in transporting this room with traditional roots into the twenty-first century. The artwork is by Jaq Belcher. *Opposite:* The chandelier, which picks up on both the linear and curvilinear elements at play, anchors the primary seating area; its mate does the same in the dining area. *Following spread:* A commissioned artwork by Eric Blum commands the wall in the dining area. The dining table with its custom oval top is a modern take on a traditional trestle table.

Opposite: A series of gathering spots for lounging and dining occupies the sequence of niches that march along the window wall of the rear enfilade. *Above:* It is always nice to include a bit of history in the furnishings. The lounge chairs by Paul McCobb speak to the power of vintage not only through the era of their design, but also because they were purchased for a previous residence and so bring those memories with them here. *Right:* In the main living room, the upholstery forms marry the present with the past in the sofa and modern wing chair. *Following spread:* For these clients who entertain often and regularly gather their large family together here, the pair of islands occupying the core of the main kitchen and overlooking the adjacent family room were, practically speaking, a necessity. The island closest to the family room incorporates a dining table with seating for casual conversation, meals, and helping with meal preparation as well. The primary island, literally large enough to dance on, features built-in storage for cooking utensils and kitchen equipment.

Preceding spread: A banquette placed flush to the second island provides one of the two styles of seating around this casual dining table. When appropriate, the use of different seating types at the table can be a design choice that appeals to both physical and visual comfort. The platinum-leafed metal hood adds a glamorous flourish. A custom hanging shelf in the window supplies yet another storage option without obstructing the view. *Opposite:* With walls of windows on three sides, the wife's office is its own glass box. A custom worktable occupies the core of the space. *Above:* A book-matched backsplash and countertop in the same marble give the butler's pantry its unique personality. *Right:* On the opposite side of the butler's pantry, a wall finished in a graphite plaster introduces a subtle contrast. *Following spread:* The use of planking on the walls and ceiling unifies the architectural envelope of the family room. That said, the dark-painted finish of the fireplace wall really performs a type of contemporary trompe l'oeil in the way it makes the television disappear.

Preceding spread: A sectional sofa and swivel chairs beckon in the screened porch off the entry, where a hanging upholstered swing offers its own invitation in the far window. Adjacent is an outdoor family dining area, a much-used venue when the weather is fine. The sliding doors lead to the pool. *Left, and opposite:* The primary bath, en suite with the primary bedroom, incorporates several of the soft, stately shades of blue and pale gray that create one of the unifying visual threads throughout these interiors. The bathtub takes pride of place in the window, where plain curtain panels work to modulate the flow of daylight and manage the degree of privacy. *Below:* In the primary bedroom, a custom screen embraces the head of the bed with an enclosure generous enough to accommodate a pair of bedside tables. *Following spread:* The silk-and-wool rug anchoring the primary bedroom layers in an understated contemporary graphic pattern that emanates a quiet energy, while another rug with a gutsy tactility all its own creates an island for the seating area banked into the window.

Local Color

City living has many different expressions, and none of them depend entirely on which metropolis people call home at any given time. These gregarious, fun-loving art collectors, for example, were anchored in New York when they fell enough in love with Nashville to decide to split their time between the two. At first, they put down part-time stakes in a very contemporary house on a hilltop overlooking the center of Nashville. When downtown's siren song beckoned, they uprooted to this spectacular penthouse right in Nashville's heart, which grounds the apartment in the skyline's vibrancy. These clients love color and wanted their living spaces here to radiate it, especially given the cityscape's rich kaleidoscope, particularly at night. Attending to this desire while hewing to our belief in the power of quiet palettes became the driving motif of our design challenge.

These clients preferred to keep the interior architecture comparatively strict and minimal, in part to relate to the building's outlines. This meant that the most powerful tools at hand to define and delineate each space were furnishings, rugs, and textiles. We built the rooms from the floor up, looking for rugs to give each room a distinct personality and a strong foundation for decoration.

The wide open main salon, which seems to extend endlessly into space because of its window wall, came into focus with a rug of amber-y oranges and deep plums on a neutral background, and graceful notes of various blues, amethysts, and purples above. Framing one corner with a custom sectional sofa scaled to fit, we shaped a conversation space in the room's core that we anchored with a floating sculptural sofa. A second seating area provides a space for more intimate groups to gather.

In the dining room, a rug washed in shades of aquamarine invited the blue tones to take the lead. The credenza's horsehair front adds in shimmers of amethyst, while the dining chairs up the ante on the purples.

The primary bedroom called out for a strong graphic wall covering to anchor the main wall. Our choice, hand-painted in oxblood with matte gold, gave the space a beautiful figurative base that also emphasized its height. The need for individual dressing rooms offered an opportunity to use architecture to create bespoke boutiques for their individual collections. The gentleman's, in the primary bedroom proper, backs up to a wood-panel-clad wall that wraps around into his closet, uniting the two spaces and balancing the wall covering's intensity. The lady's, at the end of the hall, we sheathed in pale oak with display shelves and glass-fronted, felt-lined drawers.

Our work in the kitchen was simple. The space just needed the finishing touches of pendant lights over the island, comfortable benches, and totem-pole-like carved wood stools at the bar to make the most of the view.

The evening room lives in another corner of the penthouse. Here, a rug of eye-catching angles and lines on a rich blue field enlivened with golds, ochers, and other hues set the palette. A pair of ample sofas create a draw in one corner, while a sculptural swivel chair invites in another. The bookcase offers a home for the television and a safe harbor for books, collections, and other accessories.

The two guest bedrooms extend the realm of the color story. In one, soft sages and blue-greens pull the view across the river into the interior. In the other, navy spiked with terra-cotta accents creates a firm embrace. As this penthouse confirms once again, there is nothing quite like the power of local color.

Page 231: The living room rug, awash in shades of blue and plum, was the catalyst for this room's palette of neutral tones shot through with pops of vibrant hues. *Preceding spread:* In this wide-open volume, the furnishings define distinctive areas for gathering, some small and intimate, some for larger groups. The curves of the custom sofa introduce an interesting element of movement among the room's more linear forms. A long, low, custom table provides a much-needed surface for display without interrupting the view. *Opposite:* The plum and blue hues in the dining room pull in the palette from the mountains in the distance. The textural wool rug provides the perfect complement and speaks to the area rug in the adjacent living room. *Right and below:* The strong architecture of the dining table with its three-slab base and beveled top echoes the penthouse's exposed architectural elements and the building tops in the skyline view. *Following spread:* The seating along the kitchen island directly responds to the proportions and scale of the island and the surrounding space.

Preceding spread: With a pair of deep-cushioned sofas and an inviting contemporary lounge chair and ottoman as well as a coffee table with a very handy and extremely ample surface for drinks and snacks, the family room nested into one end of the living area affords all the creature comforts needed and wanted to gather groups large and small for movie viewing, television watching, or just hanging out. *Left:* In the primary bedroom, this elegantly sculptural bronze chair stands as a welcoming piece of functional art. *Below and opposite:* The bold, graphic hand-painted wall covering on the focal bed wall of the primary bedroom generates an animating energy infused with all the beneficial vertical impact of a strong stripe. Its combination of metallic platinum paint and matte oxblood background adds to the room's recipe of texture, and the metallic paint also bounces light around the space. The border of the wool-and-silk rug speaks to the play of the linear elements throughout. The vintage Murano lamps atop the bedside tables meld organically into the room's overall palette.

Opposite: In creating and designing the wife's closet and dressing room, the aim was to make it feel almost like a boutique. The shelves are positioned at just the right height to display handbags and hats. The drawers—including glass-covered storage for jewelry and watches—afford ample space for other elements of her wardrobe. As a result, she is able to "shop" the space conveniently and easily try different options as she selects her outfits. The glass chandelier and built-in elements of LED lighting outlining the shelving system provide ample illumination and aid in the desired effect. *Above:* In the primary bath, the tub occupies the perfect window-side perch to unwind after a long day and contemplate the setting sun as it descends over the Nashville skyline. *Right:* The built-in custom makeup vanity occupies the most convenient position for the purpose, as it sits just off the wife's dressing room and outside the primary bath. As a means of pulling these contiguous spaces together, the vanity is veneered in the same pale rift-cut oak used in the dressing room.

Finding the Balance

Life evolves like the seasons, with different times beckoning for new solutions. When an offer to purchase this longtime friend and client's Southampton vacation house arose after such a life change, she could not help but say yes. We had worked on it together for years, and it was flattering that the purchaser wanted it lock, stock, and barrel. For my client, building this new house a few blocks away was the answer to the question of "What next?"

We began, as we always do, by crafting a plan to solve the basic riddles of the site, such as the sun's daily course of motion. Because the property is south facing, we knew we would need to orient the house mindfully and detail it with large expanses of tall windows to draw maximum light, the magical elixir to all spaces, deep into the interior. Two magnificent mature Japanese maples suggested a natural framing device for our plan—a double-height great room flanked by two wings or pavilions, one a private zone with den and primary suite; the other, for dining and entertaining, each with guest quarters up above—and integrated the house into the landscape right off the bat.

This client prefers architecture that is bracing, fresh, and modern—but grounded in tradition. We devised a porticoed front entry that presents itself almost like a corset. The back of the house, in contrast, opens its arms in a welcoming gesture. To amplify the flow of daylight within, we emphasized interior transparency and open connections between the spaces and the outdoors with broad expanses of tall windows and skylights over the loggia.

As someone who loves to cook and to entertain on both intimate and large scales, the client had one additional architectural goal: a kitchen as a central part of the action, rather than sequestered at the back of the house. This kitchen, as a result, stands like command central on axis with the entry to make greeting guests a breeze. It also opens to the bar as well as the dining room and the dining loggia, so guests are always within earshot.

Each room is meant to reach out and grab the Southampton sunshine. The lofty, double-height great room spans the width of the house and sets the ethereal, luminous tone. We crafted the primary suite with daylight, from the bath with its private courtyard to the glass pavilion of a sleeping chamber, which faces the glassed-framed dining room directly across the back lawn.

This client's taste has remained consistent over the years. To furnish these rooms, we decided to move in pieces and parts we had selected for her other properties, combing through an amalgam of old favorites and blending in new ones to orchestrate a cohesive interior. Carpets lay a groundwork of color—the aubergines, topazes, and soft, soft blues that spark among all the serene neutrals. Works of art from the homeowner's extensive collection balance each space, infusing the rooms with interest, character, personality, and meaning.

We shaped the connective tissue of this house, the planes above and below, and the spaces in between, to add to the emotional resonance. Planked and beamed ceilings instill intimacy in the spacious main salon; drapery softens and finishes; a limewash paint in the halls and main rooms catches the light and provides great patina.

Symmetry plays off asymmetry all the way through. From the entry portico to the bedrooms, from the window configurations to the axis that provides both spatial orientation and a circulatory system, the balance of equal, like, and opposite forms, materials, furnishings, colors, and finishes ties this home together. Who can say no to that?

Page 245: The site came with a gorgeous pair of colossal mature Japanese maple trees. In determining how best to position the new house on the property, the decision to move one of these Japanese maples to establish a symmetrical natural framing device for the architecture felt like the most organic solution. *Opposite:* Given the site's south-facing aspect, the role of the fenestration was always going to be unusually significant in the facade design because the overriding goal was to bring in as much light to the interior as possible. The covered entry is a modern take on the front porch and adds another layer to the experience of the procession to the front door. *Above:* The color palette of the settee in the front entry pays homage to the purple of the Japanese maples just outside the door. The illuminated painting is by Elisa Sighicelli. *Right:* In the front hall powder room, the light fixtures and pure geometry of the vanity provide a modern counterbalance to the traditional hand-painted wallpaper, which, with its tree pattern, connects the interior to the exterior.

Preceding spread: Because the main salon was from conception intended partly as a home for a diverse existing collection of artwork, the client wanted the room to have a richer color palette than elsewhere. The final blend incorporates various shades of straw, ecru, amber, and deep purple derived from the artworks now gracing the walls. *Above:* This client loves antiques, so each of her homes incorporates historic pieces to bring patina to the space. This antique Italian console presents a useful surface for favorite objects, like an antique stone finial converted to a lamp. *Left:* This antique commode was purchased at a flea market in Paris; the plaster bust was found locally. *Opposite:* Pieces pulled from all our previous projects compose these living spaces. The tightly spaced ceiling beams establish a human scale for the 14-foot-high salon. An artwork by Kiki Smith takes pride of place above the mantel. *Following spread:* The French doors and windows stretch almost floor to ceiling to allow light deep into the heart of the house. The two chandeliers balancing this space offer a contemporary take on the classic crystal campaign chandelier.

Opposite: This cozy niche, just off the main kitchen and right next to the butler's pantry, offers the perfect nook for a quiet breakfast or a snack or to read the newspaper with a cup of coffee. The artwork over the banquette is by Vik Muniz. The sculpture in the window is by Dustin Yellin. *Above:* Incorporating counter-height cabinetry to flank the main sink in the kitchen made it possible to avoid the wall-hung upper cabinetry that would have obstructed the view. *Right:* The client, who loves to cook and entertain, requested early in the planning phase that the kitchen be positioned directly across from the front door to ensure that even when she's in the middle of preparing or putting finishing touches on a meal, she can always be in the center of the activity when family and friends arrive. The figured quartzite covering the countertops, backsplash, and island layers a beautiful, durable surface into this room's recipe of hardworking elements; its pattern and coloration bring a wonderful, but still understated, degree of motion, adding much to the room's aesthetic.

Above: With its sprays of magnolia-inspired diffusers, the floral statement piece that is the dining room chandelier introduces much more than illumination to this room. Even when it isn't alight, it provides a sculptural presence in the high-ceilinged space, which helps bring the scale of the room back to an intimate level. At night, when the bulbs are lit, the brass petal interiors generate a warm, soft glow and a lovely reflection. *Left:* The seating group in the window creates such a welcoming place to share drinks before dinner and/or coffee and dessert after. The comfortable sofa fits neatly into the niche like a window seat. *Opposite:* The club chair is from my upholstery collection; the Italian dining chairs surrounding the new central pedestal table were brought from previous projects with this client. A pair of antique Thai wood finials in the corner, which retain traces of the lichen that has grown on them over the ages, add a mesmerizing patina, captivating texture, and subtle, unexpected touches of soft gray green to the room's quiet neutral palette.

Opposite: Dark, moody, saturated, and cooling colors drench the client's den, creating an intimate, almost cave-like retreat in distinct contrast to the rest of the light, airy rooms throughout. The paneled fireplace wall speaks to the wall of shelving opposite as the two share a similar geometry in their details. The fireplace itself is the reverse side of the one in the main salon. The artwork is by Robert Longo. *Above:* The broad horizontal stripes of the gauzy curtain panels create an ethereal, strié-like effect as they filter and diffuse the daylight from dawn to dusk; at night, when they take on a much more solid appearance, they seem to become an intrinsic part of the architecture of the room. The deep, plush cushions of the sectional sofa and the balance of the seating options beckon for television or movie viewing with family and friends in the evening or just curling up at any time with a good book. *Right:* The antique leather-topped desk fits neatly between the sofa back and the bookshelves, transforming the den into a wonderfully multifunctional space.

Above: Because the primary bedroom is essentially a glass box, and therefore quite exposed to the surrounding landscape, the draped bed made sense for emotional cocooning and security. An abaca wall covering in an understated shade of celadon infuses the room with texture; this slight hint of green helps tie the interior to the outdoors. *Left:* A pair of stairs at opposite ends of the central corridor lead up to the guest quarters. Each of these serpentine stairs features a hand-wrought steel railing finished to match the fenestration details. *Opposite:* Architecturally speaking, the primary bedroom and the dining room are mirror images of one another in structural design, face one another from opposite ends of the house, and incorporate corresponding niches for seating and lounging. In planning a design, much pleasure comes from the ability to build in these kinds of spaces within spaces. Here, the primary bedroom's seating area mimics the layout of its sibling across the way, while the individual furnishings speak to each room's form, function, and desired aesthetic.

Opposite: The primary bath has the added luxury of its own secret garden, an extremely private oasis just for the client. The brick-walled courtyard integrates a trough fountain into its architecture. When the fountain is running, the music of the water layers in yet another strain of harmony to nature's symphony. *Above:* The glass wall separating both the shower and the water closet from the core of the room incorporates a chest-high section with a sandblasted finish for privacy as well as a transparent upper tier to facilitate the view. Custom wall-hung vanities, veneered in rift-cut oak for warmth, provide ample storage and detail. *Right:* A custom makeup vanity anchors one end of the space. The photograph above it is by Anne Collier. *Following spread:* The private garden courtyard off the primary bath is intended to be a place of great serenity. The materials are quiet in the extreme, with carefully selected plantings to add texture and a little color. The garden bench inserts a functional sculptural element into the design, as well as a spot for contemplation.

Opposite: The central loggia, which resides under a beamed and planked ceiling and connects virtually seamlessly to the main salon and the kitchen, invites dining and lounging from May to October. The signature ceiling elements extend from the interior into the out-of-doors for consistency. The custom cast-concrete fireplace centralizes and focuses this covered outdoor living room. *Above:* Rattan lounge seating introduces another texture into the mix; opposing sofas dressed in performance fabrics frame the boundaries of this living space. Their pillows harmonize with the jewel tones inside. *Right:* At the heart of the loggia's dining area is a concrete dining table. It aligns with the fireplace on the opposite wall for balance and symmetry. *Following spread:* The twin pavilions—one anchoring the dining area on the left, the other, the primary bedroom on the right—extend off the core architecture of the house symmetrically. Like glass transitions, the window walls framing each space allow for light to enter the interior of the house from all four sides of its facade.

Photography Credits

Eric Piasecki: pages 67–85, 183–203
Joshua McHugh: front and back covers, pages 13, 137–65, 245–69
Lisa Romerein: pages 14–15, 17–49, 87–117
Pieter Estersohn: page 11
Simon Upton: pages 7, 51–65, 119–35, 167–81, 205–29
Tim Lenz: page 9
Zeke Ruelas: pages 231–43

Art Credits

Front cover and page 251: Kiki Smith, *Assembly*, 2009, © Kiki Smith, courtesy of Pace Gallery
Page 9: Hunt Slonem, *Butterflies*, © 2025 Hunt Slonem/Artists Rights Society (ARS), New York
Page 20: Andreas Eriksson, *Fragment*, 2015–16, © 2025 Artists Rights Society (ARS), New York
Pages 24–25 (far right): Alexandria Tarver, *New Painting #54*, 2019
Page 29: Carolyn Quartermaine, *Ligurian Riviera*, 2020
Pages 36–37: Tamar Zinn, *Drift Quartet*, 2021
Page 43: Eliot Porter, *Iceland, Portfolio II*, 1972
Pages 44–45: Lindy Smith: *Hummingbird Sage*, 2024
Page 46: Eric Ryan Anderson, *Florence*, Polaroid Photography Portfolio, 2021
Page 52: Roland Kulla, *Hackensack Double Lift*, 2010
Pages 54–55: Diego Rivera, *Detroit Industry, North Wall*, 1933. purchased through Detroit Wallpaper Company, © 2025 Banco de México Diego Rivera Frida Kahlo Museums Trust, Mexico, D.F./Artists Rights Society (ARS), New York
Page 56: Roland Kulla, *Triboro*, 2006
Page 59: Steve Penley, *Teddy Roosevelt and Rough Riders*, 2005
Page 62: Thomas Darnell, *Pouzol Sunset*, 2004
Page 68: Herman Vedel, *Massive Portrait of Frederikke Hegermann–Lindercrone*, 1919, © 2025 Artists Rights Society (ARS), New York/VISDA
Page 69 (top, right): Robert Mapplethorpe, *Italian Vogue print*, 1984; (bottom, right) Robert Mapplethorpe, *Lisa Lyon*, 1982
Page 72: Elliott Puckette, *Untitled*, 2012
Page 73 (top, right): Italian drawings
Page 79: Murat Pulat, *Innate Box*, 2013
Page 87: El Anatsui, *Metas III*, 2014, courtesy of SZ Advisory and Acquavella Galleries
Page 89 (top): Purvis Young, *People in a Line*, ca. 1980, © 2025 The Larry T. Clemons Collection/Artists Rights Society (ARS), New York
Page 89 (bottom): Günther Förg, *Untitled*, 2005, © Estate Günther Förg, Suisse/Artists Rights Society (ARS), New York, courtesy of SZ Advisory
Pages 90–91: Fred Eversley, *Untitled (Parabolic Lens)*, 1983, Courtesy of SZ Advisory and David Kordansky Gallery
Pages 94–95: Julie Nelson, *Large Pentacle*
Page 106: Andreas Eriksson, *Kris (Drill)*, 2017, © 2025 Artists Rights Society (ARS), New York
Page 108–9: Aythamy Armas, *Untitled*, 2019
Pages 120–21: Stephen Keeney, *Contemporary Mixed Media in Blue*
Pages 124–25: John Dowd, *Full Moon*
Page 127: Anonymous antique painting from Paris Vintage Market, purchased from Harbinger, Los Angeles
Page 137 (left): Henley Spiers, *Turtle & Friends*, 2019; (on console) Diane Petry, *Untitled*
Page 139: Lesley Powell, *Looking Right*, 2020
Page 145: David Dew Bruner, *Untitled*, ca. 1980
Page 152: Zac Macaulay, *Diving Girl*, 2012
Page 160: Daniel Brice, *Water, Deep Green*, 2020
Pages 162–163: BB LaMartina, *Complete Me*, 2023
Page 167 (left and right): George Goddard, *Untitled*
Pages 168–169 (left): Eric Blum, *Untitled No. 895*, 2020
Page 178: David Kidd, *Light Before Dawn*, 2020
Page 184: Lucien Smith, *Untitled*
Page 188: Melvin Sokolsky, *Bubble on Seine Kick II*, 1963
Pages 196–97 (left): Harry Benson, *Amy Winehouse*, London, 2007; (right) Peter Lindbergh, *Christy Turlington, Los Angeles, American Vogue*, 1988
Page 199: Harry Benson, *Beatles Pillow Fight*, Paris, 1964
Page 205: Jaq Belcher, *Wholeness*
Pages 212–13: Eric Blum, *Untitled*, 2020
Page 214: Thomas Hager, *Lands Traction-I*, 2019
Pages 216–17: David Burdeny, *Drift 9, Paris-Plage, Le Touquet, France*, 2004
Page 234: Vera Möller, *The Giraffe*, ca. 2016, © 2025 Vera Möller/Copyright Agency. Licensed by Artists Rights Society (ARS), New York
Page 247: Elisa Sighicelli, *Cypress Trees*, 2004
Pages 248–49 (left): Italian drawings; (right) Wim Wenders, *Holy Figure*, 2000
Page 254 (left): Vik Muniz, *The Gypsy (Magna)* from *Pictures of Garbage*, 2008, © 2025 Vik Muniz/Licensed by VAGA at Artists Rights Society (ARS), NY; (right) Dustin Yellin, *Arboreus Milexus*, 2007
Page 258: Robert Longo, *Untitled (Cindy)* from *Men in the Cities*, 1981, © 2025 Robert Longo/Artists Rights Society (ARS), New York
Page 259: Sandra Choremi, *Holy Water*, 2022
Page 263: Anne Collier, *Looking (John Rawlings)*, 2012

Acknowledgments

My deepest, most heartfelt thanks extend to our clients. Without you and your generous call to collaborate on making your dreams manifest, nothing begins for us.

Bobby McAlpine and Greg Tankersley, I can never express fully enough my appreciation for your never-ending inspiration and encouragement, and for standing beside me and supporting my evolution in this firm. To the McALPINE staff in all of our offices, your work inspires us to raise the bar for the level of talent and service you accomplish every day for our clients.

Without the skills, talent, and dedication of our Interiors Studio staff designers—Molly White, Perrin Mayne, Emily Richardson, John Anderson, Caroline Griswold, and Meredith Lovell—it would be impossible to realize these projects without your constant daily care, immense talents, and adept expertise.

My boundless gratitude to our architecture studio—Ben Lorance and his compatriot Chase Henderson, with special thanks to Patrick Derosier—for all their steadfast insight, aptitude, hard work, and ongoing pursuit of excellence in the process of shaping and building the worlds we imagine for our clients.

To Lindsay Griffy, our "cog in the machine," thank you endlessly for all you do, which is the everything that keeps our efforts and me working seamlessly. You are a bright light that helps me walk daily into this work. To Arielle Rhyne, our office manager, you are the face, charm, and grace for our Nashville office.

My infinite appreciation and respect to Cathy Crowl, Sarah Norwood, and Ashlee Bartow, our dedicated purchasing crew, for your ceaseless efforts to manifest our ideas into realities.

Richard Norris, I am always beyond grateful for your keen eyes, immense talents, and ceaseless guidance.

To those contractors and craftspeople who translate what we have drawn in two dimensions into solid, living, working dwellings for our clients, you have my many heartfelt thanks.

No project is ever truly realized, much less complete, until its surroundings are fully dressed. I so appreciate the wonderful collaborators whose talents for creating appropriate, beautiful landscapes and gardens have so enriched the homes in this book. Thank you: Gavin Duke, Perry Guillot, Mike Kaiser, Christine London, Keith Williams, Fernando Wong, and the late Carson McElheney.

For my furniture and lighting partners at Hickory Chair and Visual Comfort, you have magnanimously broadened my joy for creating in the product lines we have partnered on. To those dear designers and clients who have supported these lines, I am ever grateful to see these pieces live on in your work. Laurie Salmore, you have been more than a partner in these efforts, and I appreciate beyond measure your steadfast drive, adroit advice, and cherished friendship.

To Jill Cohen and Lizzy Hyland, my treasured book crew, you have my deepest gratitude for believing in us for a second time around. Jill, your unwavering confidence in me has been beyond a valued blessing. Judith Nasatir, thank you for having the patience and grace to give poetic words to our works.

To my indomitable, supportive team at Rizzoli, publisher Charles Miers and editor Sandy Gilbert Freidus, my appreciation is endless.

My warmest thanks to Sam Shahid and Matthew Kraus, graphic designers, for making my vision of *The Expressive Home* come to life on these pages.

None of this work would be witnessed so expressively on these pages if not for the eyes of our talented photographers: Lisa Romerein, Josh McHugh, Simon Upton, Eric Piaseki, Tim Lenz, Melanie Acevedo, Pieter Estersohn, and Zeke Ruelas. Many thanks to you all.

John Shea, my infinite thanks, respect, and admiration go out to you every day for your unflappable resiliency, insight, understanding, and most importantly, constant love.

Captions
Endpapers: Depictions of the front and rear facades of the house featured in New Beginnings.
Page 7: Intimate spaces allow the soul to rest and the mind to wander.
Page 9: A long banquette beckons all to gather.
Page 11: Collected furnishings old and new populate and turn an entry gallery into a welcoming room.
Page 13: Nothing expresses invitation better than an open door.

First published in the United States of America in 2025 by
Rizzoli International Publications, Inc.
49 West 27th Street
New York, NY 10001
www.rizzoliusa.com

Copyright © 2025 Ray Booth

All rights reserved. No part of this publication may be reproduced, stored in a retrieval system,
or transmitted in any form or by any means, electronic, mechanical, photocopying, recording,
or otherwise, without prior consent of the publishers.

Publisher: Charles Miers
Editor: Sandra Gilbert Freidus
Design: Sam Shahid & Matthew Kraus, Shahid/Kraus & Company
Production Manager: Rebecca Ambrose
Editorial Coordination: Kelli Rae Patton and Andrea Danese
Managing Editor: Lynn Scrabis

Developed in collaboration with Jill Cohen and Associates, at Sandow Capital, LLC dba JCA

ISBN: 978-0-8478-7429-3
Library of Congress Control Number: 2025936034

Printed in Hong Kong
2025 2026 2027 2028 / 10 9 8 7 6 5 4 3 2 1

The authorized representative in the EU for product safety and compliance is
Mondadori Libri S.p.A., via Gian Battista Vico 42, Milan, Italy, 20123,
www.mondadori.it

Visit us online:
Instagram.com/RizzoliBooks
Facebook.com/RizzoliNewYork
Youtube.com/user/RizzoliNY